Teaching Ballet Creatively

A pre ballet primer

For my beautiful daughter Allegra, the inspiration of all my ideas

©*Allegra Zaigh Books 2015*
All rights reserved.

Teaching Ballet Creatively

Teaching Ballet Creatively evolved out of an interest in teaching ballet to children from a child centred perspective. It consists of some of the benefits derived from ballet class attendance, and ways in which these benefits could be utilised to enhance the personal growth and development of all children.

This book is founded on the notion that children attend ballet classes for a variety of reasons; many of which are unrelated to professional dance aspirations. Parental nostalgia for ballet, a conveniently scheduled studio timetable and proximity to home may all be determining factors that influence a parent's decision to register a child for classes. If this is true, what are the ways in which a ballet curriculum could be designed to be inclusive, and meet the needs of all who attend class?

This book gives attention to the creative potential that all children possess. It explores ways in which the delicate seeds of individual artistic expression can be nurtured in ballet to develop happy, confident creative children.

Teaching Ballet Creatively offers teachers tips and ideas to make ballet lessons fun whilst teaching the fundamentals of ballet to preschool children. It is therefore supplementary reading for pre ballet teachers and those who teach creative dance to children. It covers rudimentary practices in ballet instruction and creative ways to instil in children traditional protocol. The book includes a range of games, tips and ideas to enrich a standard ballet syllabus. It suggests ways to teach from a child centred perspective to enhance a pupil's enjoyment of ballet and thrust towards artistic growth.

<div align="right">Judy John-Baptiste</div>

Table of Contents

Contents
1. Teaching Ballet Creatively 3
2. Why do parents send their children to learn ballet? 5
3. What should they be learning? 7
4. Age Appropriate Material 9
5. Class Management 12
6. Introduction to Ballet Vocabulary 16
7. Ballet Technique 20
8. Warm Up 25
9. Circle Time 27
10. Ballet Barre 32
11. Centre Practice 34
12. Across the floor 37
13. Music 39
14. Expressive Mime 47
15. Story Telling 50
16. Use of Props 52
17. Dance Games 55
18. Routine and Repetition 60
19. Flexible Teaching 63
20. Instilling Confidence in Pupils 65
21. A curriculum for teaching ballet creatively 67
22. Suggested Resource Material 70
23. Bibliography 71
24. Author 72

Why do parents send their children to learn ballet?

Ballet has often been considered to be a performing art with an identity crisis. Its history is steeped in the annals of upper-class privilege and at times struggles to align itself with modern day pluralist society. Some choreographers have yanked ballet forward kicking and screaming. But still, internationally ballet is most revered in its traditional, perhaps Romantic form above all.

Ballet's faithful devotion to tradition does at times suffer a contentious relationship with the twenty first century; the compulsion of choreographers to create new ballets is always tempered by the overwhelming appetite for the ballets of yesteryear. In the realm of dance education, the allure of traditional ballet classes for children endures.

For many, a child attending ballet classes is considered a rites de passage. Mothers all over the world usher their little treasures to the nearest ballet class. Puffy pink tutus, satin slippers and pastel pink leotards play a significant role in the children's ballet fantasy.

Mums register their children with nostalgic memories of the past; their childhood ballet lessons. They want their children to experience the wonderful world of children's ballet. Mums sigh lovingly at every clumsy gesture performed by their little girls. Precarious princess walks, butterfly runs, shaky sautés that land in a very imperfect plié are all secretly captured for posterity on the mobile phone.

Children's ballet is in fierce competition with the plethora of dance classes available to children. But despite its cultural incongruity with the twenty first century, why does ballet continue to enjoy such popularity? It may be that ballet represents for many the innocence naturally associated with childhood. The ballerina is idolised for her representation of what is good, uncorrupted and chaste. We immerse ourselves in the ethereal world of La Syphide and love the romance of sleeping Beauty. We allow ourselves to suspend reality for a while. Ballet represents an imaginary world of make believe, virtue and simplicity. This fantasy world is a place where children are comfortable and a place where parents feel safe to leave their little girls.

In its most alluring form, ballet does not offer perplexing ambiguity. It does not force us to confront the harsh realities of urban life. We know who and what Rothbart signifies in Swan Lake. The same level of clarity of character applies to Carabosse in Sleeping Beauty. No, the world of ballet is a place where no harm can fall upon children.

Classical music is sublime, but rarely offensive, rarely disturbing. The adage offers pathos, the coda is exciting. Choreography for the most part is tempered by convention and ballet iconography. Above all, in the most loved ballets, good triumphs over evil and that makes us happy.

So when the next cohort of devoted mums hasten into the dance studio, teachers know what they are hoping for. Teachers know what mums are expecting to see. They would like to see the studio transformed into a world of loving make believe where fairies and pixies rule supreme. They would like reality to be suspended for sixty minutes or less.

For the dance teacher, there are a number of issues to consider. You will need to consider the importance of fantasy against, artistic growth, merriment and technique. Do we advance technical development over personal creativity? Should we ever elevate personal expression over theoretical knowledge? It depends largely on which type of teacher you profess, or want to be. The prescriptive technician may produce finely tuned dancers, but has that been at the expense of individual creativity? Are you in favour of pre ballet classes in close alignment with creative movement sacrificing technical development? The ideal scenario would be to find a balance between the two differing concepts. They are not mutually exclusive; offer pupils the opportunity to acquire age appropriate ballet fundamentals while at the same time allowing children to nurture their own creative potential.

What should they be learning?

The content of a ballet class is mostly dependent upon the age group in class. In pre-ballet for instance a strict adherence to technique should be discouraged. Children between the ages of 3-5 may find technical exercises difficult to execute, and whilst there should be a gradual introduction to some traditional exercises, they should only play a partial role in class. Where classes are focused exclusively on technique, often children will become bored, uninspired and reluctant to continue. Feedback from parents has consistently shown that one of the main reasons for withdrawing a child from class has been due to boring repetition and unimaginative material. As such, the selection of class content requires you to be discriminating and mindful of how it will be utilised over the term of a programme.

Technical, stylistic and creative considerations reside in the teacher's domain. But, we should not neglect to remember the reason why a child is brought into class; to learn ballet and have fun in a safe, creative environment. We should remember the expectations parents have of the classes they have registered their children for. Simply put, parents are rarely satisfied if they are unable to see some semblance of movement in class that typifies ballet. They want to see ballet aesthetics. Parents who have recently registered their child for class will, the moment a plié is performed want to record the event. For a parent, each stage of a child's development is precious. Sometimes the desire to record special events in a child's life for posterity is overwhelming. Parents have been known to withdraw children from a school where recording or taking photography is not approved of. Often mothers are thinking of years to come when mother and daughter can reminisce over the lessons the little girl is currently taking in your class. Adoring parents are compelled to document significant childhood experiences. The significance of the first plié can be compared to the first stumbling steps taken by a toddler; unmissable.

When we are considering which components should be included in a class, there are many issues at hand. A pre-ballet class should initiate children into a world of proactive creativity, underpinned with child friendly stimulating content. All classes should be fun, prompting a child's keenness to return to class on a regular basis. Classes should systematically develop the innate artistic abilities of its pupils. Classes should engender confidence and nurture the natural thrust towards individual expression. This should be tempered by a flexible structure with the gradual introduction to basic technique. As such, the following elements may be considered:

1. Story telling
2. Musical exercises
3. Classical and topic focused music
4. Circle time
5. Repetition and familiarity
6. Simple Ballet technique
7. Expressive mime
8. Use of props
9. Introduction to ballet vocabulary
10. Dance games
11. Developmental content
12. Performance opportunities
13. Flexible content
14. Class management
15. Instilling Confidence

You will not be able to include all of these components in every class. It is recommended that a selection be made, and to work with them regularly during term. Don't wait until your pupils become bored and demonstrably less keen to participate in class. Revise the content regularly to ensure the children are sufficiently stimulated and happy to be in class.

Age Appropriate Material

When teaching pre-ballet we have quite a responsibility on our hands. All too often adults report negative tales about their childhood ballet classes. Many are suffused with experiences of austere, regimented classes bereft of fun. It is a miracle that decades later they return with their children to register them for class. It suggests that despite some of the negativity of experience, some parents still recognise the enormous benefits ballet has to offer and want their children to reap some of those rewards.

In order for teachers to succeed, their pre ballet classes should consider the age and abilities of the children in class. This is fundamental and will determine what children can learn and more significantly, how they learn. Teachers should always remember the value and significance of play in a child's life. Recreational play is not simply a means of leisure or a way to fill the day. For the very young especially, it is the channel through which they learn about the world around them and digest their daily experiences. It is through play that they are most engaged and their minds are best stimulated. Children enjoy playing with other children of the same or similar age. They play with toys, books, and enjoy mimicry or role play based on the behavior of others they know. These methods of learning can be utilised in pre ballet classes without compromising the main area of study; that being pre ballet. By understanding how children learn it is clear that fun and play should be an essential ingredient in all classes. This is non-negotiable for three to five year olds; for six year olds and above play activities should still feature heavily in class.

It cannot be over-emphasised, that pre-ballet is just that; pre-ballet. It is a dance preparation in anticipation of children taking ballet classes. It should not contain simplified versions of a standard ballet class. It should however contain components that develop some of the social, creative and cognitive criteria helpful to participate in ballet at a later stage. Pre ballet is suitable for children 6 or 7 years old, sometimes older if the child starts ballet at an age later than average. Basic ballet technique should be kept to a minimal with no designs to force turn out. Children should be allowed to work within their own natural turn out with acceptance of foot work in parallel. Ballet technique needs to have bones, joints and muscles that are ready to sustain turn out and all of the other rigors imposed upon the body. Their little bodies are just not strong enough and premature technique can cause pain and lasting damage. If we are to sustain interest in ballet and foster long lasting pleasant memories from childhood, ballet needs to be fun. The hard work can wait until the body and mind of a child are ready.

At a young age, children are unable to sustain any activity for long. This can be a challenge as often time and attention is precisely what is needed to teach a class successfully. For pupils who are under 5, classes normally last between thirty and forty five minutes long. Classes can last up to an hour for children who are seven and above. This change in time is a preparation for standard ballet classes to come . It is also an acknowledgement that the child's ability to concentrate for longer periods of time is improving. For 3-5 year olds, you should move promptly from one exercise to another and not wait for children to show signs of boredom. Children who are bored may become unresponsive to all subsequent tasks which can influence their participation in the class as a whole. Children love to mimic the behaviour of others. If deviant behaviour appears to be more fun than tackling the material offered by the teacher, the result could be an entirely mischievous, raucous class. Keep material brief, and interesting to avoid classes spiraling into mayhem. Avoid keeping children stationery in one place for too long or for sure they will find something to occupy the time.

Children are bursting with energy. When children are in a particularly boisterous mood it is probably futile to battle against their rambunctious behaviour and soldier on. No matter how well prepared a class plan may be, a class driven to distraction by their own excess energy will be a hard challenge to manage for most teachers. Better to abandon any preconceived class plans and improvise with games and exercises that will help expend the excess energy. Any high energy games will suffice to calm them down. Games such as popcorn, Upstage, Downstage or similar ones may work. Alternatively introduce something that will focus their minds and stimulate their attention. Problem solving tasks can assist in re-directing attention because children become engrossed in completing the task.

In a class for 3 year olds It is not particularly fruitful choreographing dance motifs. This is especially so if the dances are set within a framework of rigid counts and phrases. At this stage, it is beyond a child's capability to count and dance in perfect time and they should not be troubled to do so. These classes should be focused on creative movement only. Present simple spatially oriented questions such "can you reach the stars?" " Who can show me a flower blowing in the wind?" "Let's jump in muddy puddles and pick some leaves off the floor." "Who can walk along this line?" These types of exercises are fun for toddlers and help to engage their minds. Teachers can motivate them further by supplementing this work with additional topic based questions. "What colour is your flower?" "How many leaves do you have in your hands?" Employ suitable music for your exercises and select fun and familiar nursery rhymes as part of the class plan. Be an active participant in your class. Sit, stand and dance with your three year olds. Remove yourself from the norms of adult behaviour. Adapt yourself to their environment; learn to play, pretend and demonstrably enjoy it. Immerse yourself in the toddler world for the 30 -45 minutes you have them in class. Your class will reap the benefits. It is vital that little ones have fun and are not subjected to regimented teaching methods. As long the toddlers are participating for most of the time, the class material is meeting the requirements for the group.

The benefits of ballet are many. Ballet classes should equip children with the resources to ignite their imagination, learn the rudiments of class structure and discipline, develop their own self-expression and boost confidence and self-esteem. All of this should be mediated through a judicious syllabus with fun at the helm.

Class Management

When you are teaching ballet to a newly formed group, you are in many ways quite fortunate. You have been given the opportunity to teach children the norms and practices of a ballet class at a very early age. You are starting from scratch with a blank canvas. It is far more difficult to remould pupils at a later stage when they have amassed a host of habits (good or bad). Breaking habits that have become entrenched is laborious, time consuming and can prove frustrating if the response to change is sluggish.

It is very important that children learn the rudiments of class structure and etiquette. Left to their own devices, children will run relentlessly around the studio and fidget mercilessly when asked to stand still. They will take inordinate levels of interest in the most banal objects in the studio, and enjoy peeling splicing tape off the floor. In particular the very young may try to suspend themselves from the studio curtains or help themselves to any props in view. They will run to their parents at every available opportunity and request disingenuous bathroom visits throughout the duration of the lesson.

So, in order for you to maintain your sanity, but more importantly for your pupils to learn and enjoy their classes, there needs to be clearly defined rules and acceptable modes of behaviour. All pupils need to understand that as soon as they enter the studio there is an expectation to behave in a certain way. That said, for the most part children crave order. They will push boundaries until they are restricted. They will "misbehave" until they are taught the right way to behave. A place where no boundaries are set creates a sense of fear and insecurity. Order creates an environment where children feel safe, subsequently relaxed and free to indulge in creative endeavours. Failure to teach class norms will jeopardise their ability to learn and subsequently their enjoyment of their classes. An unruly class presents an unimpressive sight to parents and prospective clients. To the observer, it gives the impression that the teacher (perhaps unfairly so) is incompetent, and that she does not have command of her subject.

It is part of the teacher's job description to ensure that method, (the harness of content) is an integral part of dance education. It is the implementation of a formula that provides a good foundation for the absorption of class material and is a stable precursor to future dance training. Children need to have the rules and patterns of behaviour reiterated on a regular basis so that their conduct becomes an instinctive reflection of class protocol. The best time to go over

class comportment is at the beginning of each lesson in anticipation of class work. For the very young this could be presented as a game. To test their knowledge, encourage the children to remind you of the studio rules and slip in some very obvious mistakes. The children should point out the errors and be keen to do so. This can be humorous and quite entertaining.

In a ballet lesson what are the things that children need to learn? The impulse to run vigorously in the studio does tend to diminish with age, but this instinct should be curtailed. The need to run can easily be integrated into a meaningful exercise. Playing Musical Statues or Upstage Downstage both help to reduce excess energy and are of educational value. Teach children to enter the studio calmly and sit down. This is quite a challenge for 3-5 years olds but it is one of the basic drills in class. Like many of the preparatory exercises children should understand that the studio is a calm and controlled environment. For the very young encourage them to sit quietly with their legs crossed. Encouraging children to fold their arms will restrict fidgety behaviour. It is at this stage of the lesson you may consider generating a little dialogue between you and your class. Children are usually brimming over with stories to tell you and the rest of the class. If you award children with the opportunity to speak about the events that took place during the week, they may be less inclined to interrupt you when you are teaching later on.

Children need to dress appropriately for their lessons. Most ballet schools and studios have a uniform. This should be a standard requirement. Wearing a uniform orientates a child for the task to come. As soon as they are dressed in dance attire, they know that they are preparing for their dance lesson. This signals their minds to prepare for the types of behaviour that will be expected of them before they arrive for the lesson. In addition, the uniform creates a unified identity for the group. Each child psychologically learns that they are a part of this special group; the ballet group. Wearing the same clothes as all others in class gives children a strong sense of belonging. For the most part uniforms are beautiful and wearing it makes each child feel special. Children who find themselves in the unfortunate position of being the only one without a uniform will often cry, or sulk and enjoy the lesson less. They may feel less a part of the group and this can often affect their confidence and willingness to participate.

In class some children need to understand that their ballet teacher is not the performing monkey: put in place to entertain them for sixty minutes. While the teacher should always be affable, there should be an acknowledgement they have come to the studio to learn a very specific form of art. That being said, too much work will produce unhappy pupils, and possibly disappointed parents who

will remove their kids from class for the lack of fun. There should always be an attempt to find a balance where cognitive, kinaesthetic tasks are mitigated by sheer fun.

It is not fun to stand still and at a very young age standing still can be quite a challenge. In many cases it can be the most challenging task of all. To simply ask children to be still may work temporarily, but they will soon be distracted by other miscellaneous things to focus on in the studio. A child may find looking at her peers far more interesting than looking ahead. She may suddenly recall an earlier event and feel an irresistible urge to tell you at the very moment she is being asked to stand still. To familiarise children with stillness without boredom, you may need present this as a fun learning activity. Select an up tempo song and ask the children to dance at leisure. Upon the sound of a clap or the pausing of music ask the children to walk calmly to form a line and stand still. Repeat this over and over. This is a fun game that teaches children the contrast between movement and stillness. Eventually with practice, they will walk quietly when prompted to do so.

Children who have not started nursery nor attend a play group regularly, often find class structures particularly challenging. This may show itself in endless fidgeting, talking and general disruptive behaviour. But be aware that troublesome behaviour may also be a sign that the class content is insufficiently stimulating. Consider the number of children who are regularly distracted in class. If a small minority are unruly it may just be an indicator that for these children, there needs to be more attention given to class etiquette. If one child in particular is proving to be a challenge it may be wise to recruit her for class duties. This could involve her helping with props, or asking her a question that seemingly requests her advice. Giving a child responsibilities allows her to feel a sense of importance. It may also address the need for attention that may be at the heart of the problem. It may also steer her attention away from further distraction.

If there are a large number of pupils showing signs of distraction it may be that your material needs reviewing. Perhaps the content needs revising or replacing. Perhaps it is time to move the class on. From a structural perspective, ensure that your material is set in a seamless sequential fashion and the time spent finding music at the stereo is minimal. Avoid working from notes and try to learn your material. Time spent reading or searching for music is a breeding ground for mischievous behaviour. Children delight in being a little mischievous. A whole class left with nothing to do but wait, can cause a small mutiny that could be difficult to overcome.

From time to time you will encounter toddlers who are reluctant to leave the clutch of their mother's arms. There are varying opinions as to how this should be managed. Most prevalent in the ballet world is the belief that a child should be gently teased away from her mother. It is thought that with the presentation of stimulating material, a child's focus will be redirected away from the distress of separation. In being suitably engaged the child will lose her preoccupation with the absent mother and focus on the task in hand. For some children, this is indeed true. Some children are only temporarily disturbed by the exit of their parents. Once they are surrounded by exciting stimuli and other toddlers, they will be happy to join in all activities until their parents return. But children who are not yet attending nursery or any regular play group will not always settle. In these situations you will need to decide the best option for all. Pulling a child away from her parents may trigger a deluge of uncontrollable tears. A child who cries incessantly is a real distraction to other children, even if the tears do eventually stop. It is probable that all the children in the class will concentrate on the sad tearful child and not listen to anything the teacher is saying. Worse still the tears of one child may activate a studio full of crying toddlers which is extremely difficult to manage.

To mitigate this scenario, on occasion the best option might just be to allow the mother in class for a few minutes at the start of a lesson or two. This concession should be limited to a couple of lessons to facilitate a child's settling into a class. The parent should discreetly disappear when the child is engaged in the class activities. It is hoped that when a child learns that class is fun, mum's presence will no longer be a prerequisite for attendance. The other alternative is harsh but sometimes unavoidable. You will need to call the parent to take the child away from the group. This can leave you as teacher feeling terribly uncomfortable but sometimes that is the only option left. The child may just need a little more growing time before she can come again.

If the age group of your class mediates between three and five you might need to establish a set time for visits to the bathroom. This can be organised just before class is scheduled to start. As a child enters with her mother, redirect them to the bathroom if need be. Visits to the bathroom can be contagious and can impact heavily on class time and activities. Once each child has been given the opportunity to visit the bathroom they are less likely to request another visit. You may find another time suits your class better, but the most important thing is to give all children the opportunity to use the bathroom.

Introduction to Ballet Vocabulary

Children are well adapted to learning foreign languages. Sometimes children speak an imaginary language constructed from their own creative minds. They are at play. The words are totally meaningless but the conversation is conducted as though it were a language recognised by all. This capacity to switch from one language to another (albeit fantasy) is why children do not need to be mollycoddled by the translation of French ballet terms into English or any other language. Children learn languages effortlessly and this innate ability should be embraced in class.

A language is best learned when it is introduced as part of everyday language. As such the learning process is an organic process as opposed to a contrived clinical exercise. It is for this reason language learning is best achieved by visiting the country where the language is naturally spoken. This method is far more successful than learning verb formulas and grammatical structures in a classroom.

The same principals apply to learning ballet vocabulary as part and parcel of a dance class. It is just as easy to say plie, stretch to children as it is to say bend and stretch. This way you are equipping your pupils from the outset with the appropriate vocabulary necessary for their lessons now, and in the future. Children who attend ballet classes on a regular basis are comfortable with the ballet terms as this is understood to be a characteristic feature of class.

However, when a teacher calls a class to plie she should not assume that the children comprehend its meaning. It is the point at which the word is used, should its meaning be discussed and clarified. Invite the children to guess what the verb means. The children may surprise you by having worked out the meaning for themselves, but if not, you can take this opportunity to tell them.

Terms to consider for a pre ballet class*

Plié: To bend both knees
Degagé: To disengage or release
Fondu: To bend one knee, to melt
Battement Tendu: To stretch the foot
Sauté: To spring
Jeté: To throw the weight from one foot to the other
Demi: Half
Devant: At the front/in front
Derrière: At the back, behind

Bras Bas: Both arms down
Grand battement: A controlled throwing of the leg (kick)
Petit: Small
Chassé: To slide into a demi plié
Port de Bras: Carriage of the arms

Between the ages of 0-5, children are so well adapted to language learning it would be a lost opportunity to teach ballet using translated approximations in English. Give them a great start and teach them using traditional ballet vocabulary.

*UKA Syllabus

Adage and Allegro:

The terms adage and allegro provide a fertile basis for class content and language learning. Once children understand that these words mean slow and quick loosely speaking, there are a myriad of lessons that can exploit these terms.

Children are easily engaged in exercises using the terms adage and allegro. This is primarily because children love working with contrasting concepts. The movement qualities are unambiguous and readily identifiable. They understand what slow means and what fast means and how these words translate into movement. Pupils of all ages can happily participate in adage and allegro exercises without feeling the awkwardness that is sometimes associated with learning new concepts.

Introduce problem solving games where a range of ballet music is played and invite the children to guess whether they believe each track to be adage or allegro. This can be played as competing teams or individuals. Stickers may be awarded each time a correct answer is given. For extra complexity, include petit allegro and grand allegro. These games can also be played using creative movement.

For a more structured approach, set two simple pieces of choreography: one adage and one allegro for the children to learn. Once learned, the pupils are encouraged to say which is which. For the very little, discussions could be focused on the movement qualities of animals. For instance a tortoise, and a tiger or any other animals the teacher or children can think of. The children are then asked to move in ways they feel is similar to the animals in discussion. Decide whether you would like the children to investigate the two movement qualities independently or as a follow my leader type exercise. In preparing for this class pictures or toys could be brought into the class as supplementary material.

Within the framework of adage and allegro most exercises will develop an awareness of pace, contrast and speed. For additional study choose a song that gradually changes in speed. This music can also be given to children to use as part of a free dancing session where they can be left to improvise at leisure. Children generally enjoy the freedom of unguided dancing; it gives them the opportunity for unbridled individual expression. But take note that some children can become overly excited as the speed of the music accelerates and may require extra time to calm them down.

Contrast is an important feature in class to keep young children engaged, and the terms adage and allegro do this well. These terms form a vital part of dance vocabulary as do their accompanying movement qualities. Other terms such as plié and sauté are helpful when devising games to learn about jumps and provide the contrast that children enjoy working with. When ballet terms are an integrated feature of class, they are normalised and children accept them. We need to be certain that children understand them, but once they do, ballet terms can be used as a rich source for dance games as well as the means to convey movement.

Ballet Technique

Entrance into the pre ballet class represents a child's first timid steps into ballet and as such one should be mindful of its content. In its initial stages it consists of introductory ballet movements and creative movement lessons.

For three to five year olds most ballet classes consist of what is commonly referred to as creative dance or movement. Around the age of six years onwards children progress onto pre ballet which is a combination of expressive dance mixed with the rudiments of some introductory ballet steps. Because this stage represents the burgeoning of technical ballet instruction, careful consideration should be given to the presentation of content ensuring that children are not left bewildered or overwhelmed by its technical character.

In pre ballet demi plies, tendus, piques, battement jeté are entirely acceptable steps to study. Jumps such as sautés, jetés and echappés are suitable for this age group. In addition, skips gallops, spring points and hops all contribute to form content suitable for pre ballet.

A carefully prescribed syllabus equips the teacher with a solid body of material to study. Although not all, many syllabi are regulated by national validating bodies, some of whom enjoy international recognition. This helps to maintain quality of provision and safeguard children from being taught inappropriate material by overzealous teachers. Most significantly, a recognised syllabus is designed to expose children to content that progressively advances their knowledge and abilities over a period of time. The material is exacting and each level successfully completed is acknowledged by certificates that mark the occasion, and permit entry to a higher level.

However it is not sufficient to simply purchase a syllabus and blindly follow the programme. Doing that often results in monotonous, dull classes over time. A teacher should attempt to animate a syllabus with additional content and vibrant dance imagery in order to facilitate pupil comprehension. In so doing, a child is able to visualise in her mind's eye the material being presented and hence procure a greater understanding. Creative games should be included for sheer fun and extra choreography to provide diversity in class and potential recital material.

It is advised to use the correct ballet vocabulary in class. At first opportunity, children should become acquainted with ballet language. In order for children to perform ballet steps, child friendly imagery should be used to assist in understanding ballet terms in the first instance, and aid the execution of the steps. Children are blessed with vivid, creative minds that are very receptive to dance imagery. Three to five year olds are particularly responsive to dance metaphors. With this in mind a plié could be described as a window opening and closing. A piqué might be better understood by a child if it is described as someone knocking at a door. Positioning arms into first position may be described as holding a large beach ball in front of your tummy. Imagery is designed to create visual pictures in a child's mind to help her understand the tasks better, and hopefully to remember it with greater ease.

Technical performance at pre ballet stage is steeped in errors; minimal turn out (if any), in demi plié bottoms protrude in defiance, and arms happily misplaced at any angle. All errors are part of a developmental process that will improve with time and patience. Teachers should expect and accept all errors, praising constantly all attempts to meet the challenges of each exercise. Exercises should be restricted to first and second position of the feet and a very short ballet barre if any. Turn out should not be forced. Children should be allowed to work within their own natural turn out never permitting turn out from the ankles. Repetitions should be brief and feature throughout the term of study. Teachers should aim to develop their own dance imagery that is entertaining but informative. This will assist pupils in learning ballet technique, and help to create a sense of levity in class that will help promote a fun filled, enjoyable class.

Examples of child friendly dance language for three to five year olds.

Pointing and flexing actions for the feet
Hello, goodbye,
Good toes, naughty toes
Good morning, goodnight

Increased hip flexor range of movement

Sitting with soles of the feet together. Describe activity as a butterfly flapping her wings flying from flower to flower.

Inner thigh stretch with side stretch
Sitting with legs in second
Painting a rainbow. Select a paint pot from the sky and paint a rainbow with the right hand stretching from the right foot across to the left. Repeat starting from the left.

Hamstrings stretch
Sitting with legs stretched in a parallel position
Sing the Incey Wincey spider song. Walk the fingertips along the legs and back again. Port de bras movement can be performed with the second phase of the song.

Tendu
Used to help maintain the foot's connection with the floor.
Play dough under your feet
There's some glue under my shoe – try as I might, it won't undo!

Plié
Heels kissing
Let's make a diamond
Lets keep the heels glued together
Show me a diamond with your legs and stretch
Using a scarf in each hand, float them up to stretch the legs and down to emphasise the demi plie.

Piqué
Create a story about going to visit someone's home.
Perform several piqués to the front whilst reciting the following phrase:
Knock, knock, knock, knock, knock -- Who's there?
Repeat changing legs

Beat the drum and don't be glum
Tap the nail into the floor – tap until it's gone for sure

Hands
To teach children the thumb, middle finger connection
Ask them to pick petals from a flower
Ask them to pick stars from the sky
Ask them to blow bubbles through the circle formed with the middle finger and the thumb

Wrist exercise mobility
Position palms together and meander from side to side like fish swimming in the sea
 Pretend to read a book

Arm fluidity
Soaring high into the sky, (position hands as in prayer, stretch arms up to fifth position and then out to second)
Swans flying up so high (undulate the arms in second develop mobility)
Similarly arms could be described fairy wings and butterflies

Positions of the feet
Open the door. Used to introduce the turned out position from parallel.
Snappy the Alligator – Snip snap, snip snap, to turn the feet out Used to practice rotation in and out.

Positions of the arms
1st make a beach ball
2nd opening the curtains (let the sunshine in)
5th Let's see the sun

Poise and posture
Place a bean bag on a child's head and get her to walk in a straight line
Puppet strings. Create imaginary strings at the top of the head to lengthen the back
Show me a giraffe's neck to lengthen the neck

Sauté
Popcorn
Line all the children in a row, place your hands above their heads and challenge them to jump up to reach your hand with their heads.
Jumping beans
jumping frogs
Sauté like a rocket

Echappé
On a mat jump on, jump off (with legs jumping out to second)
With no mat; jump out jump in, clap, clap, clap

Jeté
Have children jump over a line. Call it jumping over the garden fence

Gallops
Gallop like a horse (facing the mirror)

Skips
Sing song " Skip to my Lou"

Rises
Fairy tippy toes
Reach for the stars
Reach for the Christmas presents on top of the wardrobe
Place the angel on the Christmas tree

Finally, introduce a curtsey or bow at the end the class to establish the norms of a ballet class.

Warm Up

The warm up component of pre ballet class serves the same purpose as dance classes in general; it prepares the body for movement. Initially it should include exercises that impose a slight raise in body temperature and gentle strengthening and stretching exercises. But for children we have the added task of presenting material in a child friendly way.

For a quick overall warm up, select a fun exercise that involves walking, marching, skipping and running. All of these could be progressively integrated into a freeze dance. Alternatively select a piece of music that accelerates in pace. Children love these types of activities and they create lots of excitement. For the very young, select circle activities where children hold hands. Sing 'ring a ring of roses with walks developing into gallops for instance before they sit down. Warming up the body reduces the chance of muscle soreness due to premature exertion and possible muscle strain. There are plenty of musical options available especially designed for children's ballet. Your teaching style will probably dictate the choices you make.

In most pre ballet classes the remainder of the warm up section is performed sitting on the floor. This can be done in rows facing the studio mirror or in a circle where the children are looking inwards towards the centre. For three to five year olds especially the circle structure is preferred. For this group, position place spots sufficiently apart to perform exercises where arms and legs can be fully extended. Place spots give children a sense of security; they have a spot of their own but still very much part of the group. This sense of belonging can be developed further by giving each child in class a unique place spot that they use each time they attend class. Use spots with a variety of colours for instance that you allocate to each child each term.

Another important component of the warm up will involve mobilising the joints. Here are a few examples of how mobilisers can be presented to class. Simple shoulder raises for the very young could be described as shoulders reaching for the sky and then coming back to the ground. For neck mobility ask the children to smile to your neighbour; first to the right and then to the left. Mobility of the arms (shoulders, elbows and wrists) may be visualised as bird flying in the air . For the very young you could ask the class where they thought the swans were going, how many swans were there and how long would it take to get to their

destination. To point and flex the feet say "good morning toes ". Tell the children that the toes are not yet ready to wake up and they should bid them goodnight for some more rest. Repeat this scenario a few times embellishing the story each time.

For a side stretch ask the children to reach up and pick stars from the sky and place them on the tips of their sleeping toes. They should be sitting on the floor with legs in a wide second position. The stars collected should be placed on the opposite foot i.e. right hand to left foot and left hand stretching across to right foot. For a spinal stretch ask the children to crouch down onto their knees and pretend to be a sleeping cat. They stretch their front paws in front of them and recoil back again. Extend this exercise to stretching the legs behind them while arms are tucked in and head down. One leg should be stretched after another. For older children combine a leg and an arm stretch simultaneously. For extra fun, create a story about the cat; is she sleeping because she has had too much to eat? Is she tired because she has been chasing lots of mice? To strengthen the back, lie flat on the stomach partially arching the back with arms in second and legs extended off the floor. Tell the class that they are airplanes flying around the world. Ask the children where they would like to go and then set the group off for departure. Relax on the floor once the planes have landed and then take off to another destination.

There are a wide range of exercises that are easily adapted for children's classes. The onus is upon the teacher to find the correct imagery for each exercise. Using imagery in dance is a standard teaching tool and can be used for all pre ballet pupils. The older the children are, the more refined the imagery should be.

All selected exercises should form part of a routine that is practised every week. However repetitions should be brief to avoid overstretching and overwhelming muscle groups. Do not encourage children to work to their maximum. This applies to strengthening, stretching mobilising and performing exercises that elevate the body temperature. Between four to eight repetitions should suffice with exercises moving on smoothly from one to the next. Because of the brevity of each exercise, it is essential that music should be prepared sequentially to avoid gaps allowing for fidgeting and the body down to cool before the warm up is completed.

Circle Time

Circle time is a well-established feature of nursery school education. Its endurance over time is attributed to the many benefits derived from this learning format. It is where children are given the opportunity to communicate on a level playing field, where mutual respect for all participants is cultivated and for the very young, the basic norms of class is slowly learned. In a circle, very young children enjoy a greater sense of security; nobody is left isolated at the end of a line. It is a format where teacher and child are not subject to the hierarchical norms of the classroom. It is an egalitarian structure where children are given the opportunity to express themselves openly and give opinions on an array of topics for the rest of the group to listen to and comment upon. From the circle format children learn many of the social skills needed in class. They learn to adopt appropriate behaviour in a group, to value the opinions of others and the confidence to speak publically.

Structurally, circle time has other benefits. There is no downstage nor upstage; there no front, no back and no best spot. Every child can be clearly seen and heard without exception. The teacher is also clearly visible to each and every child. Using this format facilitates class management and makes for less disruptive disturbances in class. Each child's focus is drawn towards the centre of the circle and as such is less distracted by miscellaneous things in the studio environment.

Typically in pre ballet classes, circle time is utilised as a foundation for warm up exercises. Characteristically— hamstring stretches, feet flexibility exercises, back stretching and other mobility exercises are performed routinely. These and other exercises make good use of the circular teaching structure and should be maintained as one of its core components.

Children will often disrupt the flow of lessons to discuss issues unrelated to the task at hand. They may want the whole class to know or just the best friend sitting next to them. These compulsive outbursts could be partially if not totally stemmed. At the start of a lesson circle time could be used as a means to allow all children the opportunity to say personally relevant things about their week prior to class. This also includes things scheduled to take place in the future and issues related to class. Allowing children a time slot to unburden themselves may have the benefits of a lesson that transitions harmoniously from one activity to another without interruption. Children learn there is a time to talk, a time to listen and a time to discuss. More significantly, establishing a time to talk sends a signal to all children that they matter, and their opinions matter.

This develops trust in class and helps children to bond and work together. If children are permitted talk at a designated time the overall class will benefit and less time will be spent curtailing pupil outbursts.

The use of circle time to teach standard ballet material is not to be neglected. The suggestion is that ballet should make better use of this class component. It should include pupil talking time and teacher talking time. Teacher talking time should revolve around responses to the utterances of children and issues specifically related to lessons. This might include amongst other things, theatre visits, exams, term holidays etc.

The concept of fun should be integrated into circle time and as such should also include exercises that create light-heartedness in class. Some exercises should be included purely to create laughter and enjoyment. Consider name clapping. Start a clapping sequence with the group and then sing out the name of each child in time to the rhythm of clapping. The names should be called out sequentially around the circle. For extra fun progressively speed the clapping up. Alternatively, Chinese whispers can be used for all pre ballet age groups. Children will be amused when they hear the final sentence after the whisper has gone full circle. The nursery rhymes "Heads, shoulders, knees and toes" or "Row, row row your boat" are ideal for three and four year olds and lend themselves well for creative movement. For belly laughter for all, encourage the children to make facial expressions. These can be the standard happy, sad, angry tired expressions. But simple facial expressions can become hilarious when they are extended to making funny faces. Add funny sounds to each facial expression and the children will love their circle time. Similarly create a circle of smiles by each child being asked smile to each other with the smile travelling sequentially around the circle. Duck, duck goose is a favourite in nursery schools and reception classes everywhere. It is a good old fashioned game but be aware that this game can generate excessive excitement and should be included with caution. In contrast, for children who are four and above you can use circle time to teach traditional ballet gestures and then test them each week. 'Simple Simon Says.....,' can be adapted to teach basic ballet positions and is a fun way to test vocabulary if there are no teacher demonstrations. As an alternative play 'Simple Simon Says..,' using incorrect gestures or ballet vocabulary. This awards children the opportunity to correct your mistakes and demonstrate their knowledge.

Placement spots fashioned in a circle are recommended for three to five year olds. This allows the teacher to create sufficient distance between pupils for exercises and children learn where they need to be at the beginning of a lesson. Ideally music should be prepared on a playlist or cd. This avoids the teacher needing to get up in between exercises to search for relevant music. Circle time

should last about 10 - 15 minutes. This is dependent on how many children there are in a lesson, the average age of the children in class, and how much time is attributed to talking. Three to five year olds get restless very quickly and so with this in mind, time spent sitting should be considered carefully. If however, talking time is fertile, you may need to abandon one exercise in your class plan to maintain the flow of the discussion. The value of self-expression to boost self-confidence, should not be underestimated and should be a valued component of class. Especially for the timid, all attempts to speak and contribute should be received with positivity and support.

Keep circle time fairly consistent. Children need repetition to understand structure. Get the children involved in putting placement spots away. Most three to five year olds enjoy participating in all aspects of class and tidying is one of them. As is the case with all aspects of class, circle time needs to be planned. However, always be prepared for the unexpected and maintain a fair degree of flexibility. It is unnecessary to complete everything scheduled in a class plan. If something planned is clearly not focussing the children's attention, be prepared to present something else. Once circle time is finished the transition from sitting to standing should be choreographed. This clearly signals the termination of one activity and commencement of another.

Things to be included in circle time:

1. Hamstring stretches.
 Sitting with legs extended to the centre of the circle. Invite the children to sing the ABC song. With both hands children point to their belly buttons and then to their toes.

2. Hamstring stretch
 Sitting with legs extended to the centre of the circle. Invite the children to sing the song 'Row, row your boat'. Tell the children that they are in an imaginary boat rowing away from a crocodile. To extend this activity tell the children that they are in a swamp and there is an alligator and we have to be very quiet and row slow to get by

3. Sitting with legs extended to the centre of the circle. Invite the children to sing the song Incey Wincey Spider. For the first line stretch your hands to the ceiling. With the sentence 'Down came the rain,' use your fingers to imitate rain falling from the sky. Bring your hands down to the hips. With the sentence ' and washed the spider out,' shoot the arms towards the toes. Perform a ports de bras for the line ' out came the sun and dried

out all the rain. For the final line 'Incey Wincey spider climbed up the spout again,' bring the knees to the chest with the head tucked in.

4. Facial Expressions
 Say to the children "Show me your…………….face". You can use a variety of facial expressions such happy, sad, angry sleepy.

5. Giggle exercise
 Ask the children to tickle their knees, shoulders noses, toes or any body part they can reasonably reach.

6. Inner Thigh Stretch
 Organise the children to sit with the soles of their feet touching and their arms in first position with their heads down. Explain that they are little balloons that pop. The sudden pop thrusts their legs into second position with arms in 2nd

7. Inner Thigh Stretch
 Sitting in second position ask the children to reach for their imaginary pots of paint in the sky and to collect their paint brushes. Ask each child what colour paint is in their paint pots and sing the nursery rhyme I can sing a rainbow. With paint pots sitting in front of them ask the children to dip their brushes into the paint and brush their colours across the sky from the right foot to the left.

8. Spinal Flexibility
 Have the children lie flat on their tummies with their heads facing in towards the centre. Tell them that they are on holiday and swimming in the sea. Show the children how to swim in the sea using their arms and legs. Encourage the children to say where they are on holiday, to describe the water and to say where their parents are.

9. Foot Flexibility
 Sitting with legs extended to the centre of the circle. Invite the children to sing the following song. 'Good toes (feet pointed) naughty toes (feet flexed) give them a clap. Naughty toes ugh……We don't like that!!'

10. Side Stretch
 With legs crossed ask the children to pick the stars from the sky.

11. Inner Thigh/ Spinal Stretch
 Sitting upright with the sole of their feet touching, ask the children to

smell their feet. To extract the maximum of giggles from this exercise the teacher will need to do the same and then straighten up waving the air in front of her nose saying 'pooh!'

12. Hip Joint Flexibility
Organise the children to sit with the soles of their feet touching and their hands holding their ankles. Show the children how to move their knees up and down keeping the feet stuck together. Tell them to flap their wings like a butterfly. Consider asking the younger children 'What colour are your wings?' or 'where are you flying to?' or 'what birds do you know that can fly?' For extra giggles ask the children if animals like elephants can fly.

13. Head Isolations
Rather than asking children to look right, left etc. ask them to look at the door, look at the windows, or anything in the studio they can focus on.

14. Dance Improvisation
Select two children from the group to dance together in the centre of the circle. Ensure that both children dance. Get the children to dance individually (solos) if they are able to.

15. Rhythm development
Have the children sit in circle . On the first count the children slap the floor and the second beat they clap above their heads. For greater enjoyment add some fun words for instance, pigs and pixies. These could be created by you the teacher or by the children. Give each child the option to add fun words. Create a variety of rhythms using the phonetics of words for each rhythm.

16. Posture
With legs crossed in a circle, tell the children to sit up like beautiful ballerinas. Alternate this with sitting like a frumpy frog. Use facial expressions to accentuate the differences.

17. The Beginning of turn out
Sitting with legs extended to the centre of the circle and toes pointed in a parallel position. Open the book (feet flexed) turn the page (turn out), close the book (rotate back) and put it down (toes pointed).

Ballet Barre

The introduction of the ballet barre is an exciting component for pre ballet children. For children the barre is symbolic of a real ballet class and makes them feel very grown up. The time spent at the barre is short with a few basic ballet steps, but its inclusion in class for some, represents a significant transition in a child's development in ballet.

The stage at which the ballet barre is introduced is very much dependent upon the syllabus used for classes and teacher preference. Some syllabi do not use the barre at all until children have reached grade one. Others permit a short barre consisting of some basic ballet steps. These steps usually include positions of the feet; namely first and second, tendus, and demi plies in first and second position. In most cases the children have both hands placed on the barre, performing all exercises en face; facing the studio mirrors or wall. This stance helps sustain balance, and assists in holding the degree of turn out they possess. It should be noted that turn out should never be forced. It may cause injury (especially to the knees) and set the path for poor technique and bad habits that may be difficult to rectify. Nevertheless, pre ballet barre work is a simple precursor to performing general ballet barre exercises and allows children to become familiar with its use.

In pre ballet classes some six year olds are still grappling with class discipline. For some the barre is a miniature climbing frame to swing, hang and goof around in general. In the initial stages children will need to be taught how to stand at the barre. It sometimes helps to familiarise children with the barre using fun based exercises that they will readily enjoy. The exercise 'Baboons and Ballerinas' helps children transition from cavorting to become the poised dancer at the barre. Children are given a short period of time to frolic around the barre and play as they please (like baboons). Fun, up tempo music is used for this part of the exercise. Upon a signal they become ballerinas and all inappropriate behaviour around the barre is curtailed for the start of barre practice. The selection of music for the second part of the exercise underpins the request for a change of conduct and asks the children to compose themselves in preparation for the ballet barre.

The pre ballet barre employs basic movements. Teachers begin to pay attention to technical development and tentatively correct errors in performance. Children should not be bombarded or overwhelmed with technical information. Much of it will be difficult to grasp for most. Use of imagery is helpful to create a mental image of the task in hand without appearing over bearing.

Ask children to keep their Knees over the toes in demi plie, keeping bottoms tidy and quiet as they bend. In order to work towards hip alignment tell children that their hips mustn't wobble in tendu. All exercises at this stage are simple, offering rudimentary corrections that are absorbed over time. Tendus are taught from first position pointing out to second and then closing back to first. Rises and then lowering the heels may be taught in first but may be preceded by the same exercise being performed in parallel. This gives children the opportunity to build strength through the ankles without the additional labours of turn out. Children experience less difficulty with alignment of the legs in parallel. The intention of these exercises is to ignite a spark of technical awareness. With time and experience children will learn to apply the corrections given by the teacher.

For some children, the barre is akin to a large prop to have fun with. It is a fun piece of equipment and adds a little excitement to class. As long as children learn how to use the barre this perception is fine. Keep the barre work brief to avoid boredom. It is advised to keep the repetitions short with little variation until you are certain of pupil competence at the barre. Maintain the 'special status' of the barre and children will look forward to it each week.

Centre Practice

Exercises that are practised at the barre are designed in such a way to assist a child with centre practice. While some schools choose not to use a barre, centre practice is often the place where one observes the fruits of a child's labour at the barre. Centre practice has a direct correlation with barre practice. At the pre ballet stage centre practice should include some simple ballet steps that are not technically overwhelming. To nurture the creativity of children this material can be supplemented with a range of activities that hold the children's attention and keep them stimulated.

Children are in constant need of mental and physical stimulation. They have an insatiable thirst for things new, things novel, and are easily bored. For most pupils in pre ballet classes it is unwise to have them placed statically in the centre of the studio for too long. At ages six and above they are more adept at standing still. They have a greater capacity to concentrate and have better control of their bodies in comparison to their younger counter-parts. But even for this group standing in one place for too long is not fun. This may give rise to fidgety behaviour and talkativeness whenever possible and ultimately reduce their focus on subsequent material.

For centre practice demi plies, piques, battement tendu devant and simple ports de bras are entirely acceptable steps to study. Jumps such as sautés, spring points and echappés are also suitable for allegro combinations for this group. The material should be kept fairly consistent with occasional variations to keep the pupils sufficiently challenged. Use popular up tempo music, and songs adapted for dance classes. Classical music composed specifically for children is also a good option for centre practice.

To make centre practice more appealing consider adding mime, gesture and games to supplement technique. These additions keep the class content moving along and children are free to move around, make better use of the studio and are liberated from the static position.

Teaching children the basic gestures from well-known ballets for instance makes good use of centre practice time and is a welcomed departure from technique. Take a short excerpt from a ballet and focus on the gestures used in the work. Gestures such 'I promise' 'beautiful' 'love' and 'crying' are stimulating material found in a variety of ballets. This type of study encourages self-expression, and contributes to a sound movement vocabulary that pupils can develop and have fun with. Encourage children to make up their own mime

scenes and ask the rest of the class to guess what is being performed in front of them. These exercises can be developed further with the use of music.

For a wide range of ages, simple mime can be used for children to initiate their own creative sketches. Set the stage for a simple mime scenario and prompt the children to take the story along a narrative journey. All children should be encouraged to contribute. Ask a pupil volunteer to lie asleep in front of the rest of the group. Start a simple story. "This is sleeping beauty and she is sleeping very peacefully. Why is she so tired?" Spontaneously, children will abound with creative explanations, all keen to help the story along. These types of exercises ignite the imagination of children, and can give you a little insight into the things that are significant in their lives. Children talk about what they know, what they have seen or what they have experienced.

In the same vein, improvisational mime can also be used to discuss issues that are relevant to the class. The starting line could be the subject of a pending recital or the summer holiday. The most important thing in these exercises is for the children to actively participate and enjoy the task.

In addition to ballet technique, mime and gesture, games are often a useful resource for light relief. But consider carefully the function of each game and use them advisedly. Some can reinvigorate children (Upstage Downstage) and others can calm them down (Sleeping Fairies). Make sure you are aware of the effects games may have upon your group.

After a series of technical and mimetic based exercises, consideration of specific dance routines should be incorporated into centre practice. This might include the development of basic enchainement learned previously and brought together in various forms to challenge and advance the skills of the pupils. The dance sequence represents the final component of centre practice, but its use extends past the studio. It is advised to think in advance of ways this material can be utilised for end of year recitals. Planning ahead avoids pre performance rehearsal cramming and reduces anxiety for all involved. Putting together an eclectic dance performance based on different enchainement with varied music can be an acceptable culmination of a year's work. This is a simple method to accumulate performance material and places the least choreographic demand upon the teacher. An alternative option would be to start with a well-known story, fable, or ballet and work with that theme throughout the year. Stories such as Snow White, Alice in Wonderland or Cinderella lend themselves well and there is a good range of music available to choose from. The latter choice requires more planning, closer scrutiny of the music and greater observance to choreographic detail. The choice is for the teacher or studio to decide. In either

case the onus is upon the teacher to present on stage a well-rehearsed, confident group of pre ballet pupils for all to see and enjoy at the end of the academic year.

Across the floor

Getting children to dance across the floor is an intrinsic part of class and is a good opportunity to teach a sense of order and protocol. Although very much determined by age, children will need to be taught how to form an orderly line, how to wait their turn peacefully, and then to travel sequentially across the room. All of these practises are managed well by children from 5 years but the younger ones will quite naturally struggle to know when to execute travelling sequences, and co-ordinate time and rhythm in space. If the group is quite boisterous it might be advisable to arrange the children in a line sitting on the floor with legs crossed. Call out the name each of child to stand in preparation for the exercise. Most of the time you will need to prompt three to four year olds with a gentle nudge to have them move along and perform the required travelling step.

Three to five year olds travelling across the room can be helped by the use of props that dictate the pathway to be taken. Setting out a clear line with the use of rope, string or gaffer tape can assist in restricting the direction of a princess walk. For the development of poise, skill and posture, place a bean bag on top of children's heads as they walk. Tell the children that they are wearing a beautiful crown that must not fall. Children will find the challenge of this exercise exciting and participate enthusiastically. Strategically placed hula hoops can help teach the rudiments of jetés and sautés. Ask the children to jump from one hoop to another without stepping outside the hoops. Place a prop on the floor to add fun and excitement when teaching jetés. Place a teddy bear or a stack of bean bags for the children to jump over encouraging one leg to follow the other. Showing the children where to start and where to end can be controlled by setting up a visual reference point to start as well as a destination point to conclude each exercise. Place spots can be used initially, eventually replacing them with a less obvious start and finishing line. Over time with practice and familiarity of the exercises these markers will not be necessary.

A pre-ballet obstacle course is great fun for all pre ballet pupils. This can be arranged with or without a theme running through the exercise. Organised on a linear pathway, place a series of exercise stations where a specific task is asked of the pupils to perform. For instance the first station might involve skipping around a hula hoop, the second, sautés in a hula hoop. The next station could

involve standing in with one leg in a retiré position to test balance ability, and the last, travelling to a place spot for a final curtsey. The obstacle tasks are easily adapted for the younger ones and they are fun because the tasks do not have to be time bound. They can happily plod along from one station to another without the added pressure of counting and performing in time.

The use of a parachute is a familiar favourite for preschools. The need for team ship for all to benefit from this prop is why it is a longstanding favourite. There are additional benefits for pre ballet. This is not strictly speaking an across the floor prop, but it can assist with the development of rhythm, movements in synchronisation and timing for some steps that would normally be practised across the floor. Parachutes are helpful in teaching chassés and gallops. The children are required to face in towards the parachute and learning is initiated by simple side step walks which eventually graduate in speed and elevation. Ballet walks can be practised by children holding the parachute with either the right or left hand and then moving in a synchronised pattern either clockwise or anti-clockwise. The Introduction of creeping movements contrasted by high, elevated stepping sequences are fun especially when a narrative scene is set. Walking in the jungle or shopping at the supermarket for instance, are useful because they inspire the creative imagination of children while learning standard dance steps. The complexity of these exercises and many more are subject to teacher creativity metered by pupil age, experience and ability.

The range of 'across the floor' exercises in pre ballet are quite varied. But most significantly whatever is selected the pace should be moderate, allowing time for pupils first to comprehend, execute and enjoy the exercises. Skipping exercises in pairs are extremely enjoyable for children. Often however, skipping for many children under four may prove to be quite a challenge. They may need special assistance in learning this travelling step. This would generally involve the teacher standing behind a child, holding both hands above her head as she raises one leg after the other to a parallel retiré position. Children generally find galloping in pairs fun and less of a technical challenge. Pony trots, chasses, walking on tiptoes and clapping and walking are all travelling steps that are well suited to pre ballet travelling sequences. As children get older and more experienced, a combination of these exercises will provide choreographic complexity at a level that is manageable for their age.

Music

A discriminating choice of music for your classes could give children access to a world previously unknown. Music has the capacity to impact learning because of the ways in which it can influence the sentient response. It can invigorate children to work enthusiastically in class, or sadden them to tears. In class we require music to play a constructive role and assist children in their ballet learning.

The music choices a teacher makes can contribute to the theoretical understanding of ballet technique and encourage children to perform the right movements at the right time. Learning a lyrical balancé sequence is made easier when performed to a pleasant ¾ waltz. The music draws attention to the rhythmical nuances of the step and makes the lilting motion easy to identify. When a pupil does not fully comprehend the mechanics of a specific time signature, a well-constructed piece of music will reveal pattern effortlessly.

During the early struggles with a challenging enchainement, often it is the music that carries the dance pupil to the end of the choreography. Music can inform a pupil when to start and help identify the most salient parts of the dance even when the choreography has not yet been properly learned. It helps the pupil to improvise (albeit temporarily) unknown sections safe in the knowledge that where knowledge of content is deficient, rhythm holds strong. Through practice and repetition, a command of the choreography will replace the impetus to improvise and musical accompaniment will become an enriching supplement to a well performed dance. In this way, music can help minimise a pupil's feelings of ineptitude when learning something for the first time, and contribute toward a feeling of satisfaction when triumphs in dance are achieved.

The type of music a teacher selects for class is quite significant and can determine how successful classes become. Very young children respond quite naturally to music, although often the instinctive urge is simply to run aimlessly. But children become sensitised to the differing effects music can have on their moods. They are able to respond to the jovial tones of a sprightly allegro beat and feel how this contrasts to the muted timbres of an adage. Their responses to music become sophisticated and their listening skills in music become an invaluable tool for dance.

At its most basic, pupils need to develop the ability to break down and identify the various components in music. They need to be able to recognise rhythms and integrate movement motifs with appropriate timing. Some pupils are lucky and are naturally able to dance in time to music. But others need this skill developed. Pupils of the latter group, who have had no musical experience will

inevitably struggle with group dances, working in canon, unison and many other dance structures where precision in timing is needed. So what kinds of exercises are needed to enhance an awareness of musical rhythm in class?

As soon as children start ballet lessons, part of the programme should include rhythm practice. At a very young age (from about 3) simple clapping exercises should be incorporated into class material. The very young should start with simple time signatures such as 2/4 to familiarise them with musical beats. Group clapping without any accompanying music is a good way to get pupils familiar with rhythm. From time to time there will be a child who cannot clap alongside the others in time. This is the child who will experience difficulties with rhythm generally. But with practice and patience all children will be able to clap a simple 2/4 rhythm

Gradually over time you will need to provide additional challenges for rhythm activities. The 2/4 rhythm can be used as the basis for simple dance exercises; marching for instance with directional changes for variety. Additional progression can be achieved by presenting to children different time signatures to work with. Introducing simple 3/4 clapping sequences provide practical experience and a step towards greater knowledge. The ¾ rhythm is an important rhythm because it is the time signature for the waltz, a very commonly used musical phrase in ballet. The 3/4 rhythm is easily utilised for movement material in a variety of ways. For older children you might consider discussing balancé, a traditional ballet step that is perfect for 3/4 class material. For further development you can teach your pupils an age appropriate balancé motif to learn. Alternatively you can give your pupils the opportunity to choreograph their own dances using balancé or the waltz.

Clapping is a proven method to develop a good foundation for understanding musical tempi. The gradual inclusion of 4/4, 6/8 and perhaps other more complicated rhythms can be a regular feature of ballet classes for the young child.

Below are some musical exercises to consider for ballet classes suitable for children from 3 years old and up.

2/4 Exercises

1. Have the children sit in a circle. On the first count the children slap the floor and the second beat they clap above their heads. For greater enjoyment add some fun words. Pigs for the slap to the floor and snout as

they clap above their heads. The words can be selected by you the teacher or by the children. Give each child the option to add fun words.

2. Marching. The children are left to march randomly around the room with or without clapping. A fitting piece of music could also be added to the exercise. This may also be an opportunity to line the children up and allow each child to march individually across the floor from one side of the room to the other. This exercise can be developed further by omitting a beat and requesting the children to stand still on the absent beat. I.e. Count 1 march, count 2 march, count 1 freeze, count 2 march. This latter exercise can be quite a challenge and might be better suited to older children.
3. Using instruments. Drumsticks are ideal for 2/4 exercises. This can be performed sitting in circle where the floor is used as a drum. Alternatively the drumsticks can be beaten against each other.
4. Playing hopscotch in the studio. Structure the exercise in a line; one child following directly after another. For younger children you can restrict their jumps by using hoops set along the floor or placement spots.
5. Clap the polka step commonly associated the early grades. First clap rhythm and then dance the rhythm to a very basic dance pattern. The traditional polka step should be deferred for older children but simple variations may be choreographed.
6. Any of the above exercises can be used with accelerated speed to develop skill and add excitement.

3/4 Exercises

1. Clapping. Form a circle with the children sitting on the floor. Slap the floor count one, clap two, in front of the chest, clap three over the head.
2. Painting a wall. This is a good exercise for promoting wrist flexibility as well as rhythm practice. The children are asked to pretend that they are painting a wall with their hands. For younger children, you could another dimension by asking them the colour of the paint they are using and what they painting.
3. Sequential group clapping. Organise the class into 3 separate groups. Each group performs one clap only to create the ¾ rhythm. This exercise can be made more challenging my adding additional claps in each of the three groups.

4. When pupils have a clear understanding of ¾ the above can be converted into simple dance motifs.

5. Tulips and butterflies
Separate the group into two groups. One group sways like tulips (or any other flower) in the wind. The second group runs in and around the flowers using their arms as butterfly wings. The respective groups move in accordance with a 3/4 time signature rhythm . For instance 123, 223, tulips sway in the wind. This followed by the butterflies flying around the tulips on counts 323, 423.

4/4 Exercises

1. In pairs children hold right hands only. They skip clockwise for four beats and then change hands and then skip anti-clockwise.

2. In pairs holding both hands facing each other, the children gallop across the room in one direction and then back without missing a beat.

3. Clapping
Form a circle with the children sitting on the floor. Slap the floor on count one, tap their knees on clap two, clap three, in front of the chest and clap four, over the head.

4. The BINGO song is often used for children in nursery and early primary. This song is well suited to providing an advanced musical challenge for little children.

There was a farmer who had a dog,
And Bingo was his name O.
B I N G O
B I N G O
B I N G O
And Bingo was his name O
(no clapping)

There was a farmer who had a dog,
And Bingo was his name O.
*(1Clap)*clap, I N G O
*(1Clap)*clap, I N G O
*(1Clap)*clap, I N G O
And Bingo was his name O

There was a farmer who had a dog,
And Bingo was his name O
(2 claps) clap, clap N G O
(2 claps) clap, clap N G O
(2 claps) clap, clap N G O
And Bingo was his name O

The game continues on in this vein until most of the song is reduced to clapping.

There are many ways and ideas to teach rhythm to children. Some of them have been noted above. For sheer entertainment invite the children to make funny faces on a particular beat throughout some of the exercises noted above. This addition is extremely popular. Get the children say bananas or any laughter inducing words to create humour in class. Avoid reprimanding children when they don't get the beats right. Given time, it will all fall happily into place. To confirm the children's knowledge of time signatures, test them with questions. Clap a rhythm and see if the children are able to identify it without any prompting. Alternatively, ask the children to clap a 2/4, 3/4 or a 6/8; if they can, your job is mostly done.

Nursery rhymes are well adapted to dance and can be used to teach an array of dance movements. Children can pick up them up very easily. Often, they will surprise you by the pace at which they can learn a song. Through simple rhyming songs children can develop a range of musical skills for dance. Through simple songs children are able to learn basic rhythms. This is because nursery rhymes in particular, tend to have intrinsic repetitive rhythms that are memorable. Simple rhythms are attractive to children and as such the call to repeat them requires little persuasion. As children learn their songs, simple dance motifs can be added. Making an association with song makes dance learning easier. This facilitates learning choreography and subsequent performance material that can be used in recitals.

In addition to learning about music there are some significant emotional benefits from children singing songs. Participating in things familiar like singing songs gives children a sense of comfort. Children enjoy nursery rhymes and this makes them feel happy. When children are able to sing nursery rhymes without assistance their self-esteem is enhanced and their confidence is boosted. When children recite nursery rhymes as a group, they develop a connection with

each other and a sense of belonging. This bonds the group and gives each child an identity within the class. Placed in a happy environment, children are more likely to learn, successfully. When children feel good about their learning environment, they are more likely to participate regularly.

The lyrics in music can be used as a foundation for dance. For Example clenching and releasing your hands can exemplify the twinkling stars in Twinkle, Twinkle Little Star. These types of movement help children to develop an awareness of their bodies. Songs such as Head, Shoulders, Knees and Toes, draw attention to specific body parts and follow a choreographic pattern; starting from the head and finishing at the toes. The traditional nursery rhyme, I'm a little teapot is a known favourite for children's ballet lessons, as the lyrics dictate the movements to be performed. Alternatively, the lyrics of a well-known nursery rhyme can be withdrawn totally and replaced with new phrases to suit needs of the class. Frere Jacque, Frere Jacque can be sung as 'Plié stretch and, Plié stretch and, Piqué close, Piqué close'. The variations are immense, limited by your imagination only.

Nursery rhymes can be used as a foundation for narrative mime; storytelling through refined every day movements. Rhymes such as Little Miss Muffet or The Grand Ol'Duke of York are known to most children and as such are easily adapted for ballet classes. To add drama consider introducing simple instruments as accompaniment.

For the very young employ a parachute and sing songs such as 'Ring a ring of roses' and other songs that give specific movement directions. Children love parachutes and they keep children in tow, and actively engaged. Using a parachute makes easy teaching for travelling steps such as butterfly runs, gallops and simple walks.

Nursery rhymes suited to ballet lessons

1. Head, shoulders, knees and toes
2. Hickory, dickory, dock
3. I'm a little teapot
4. Hokey Cokey
5. Incey Wincey Spider (Itsy Bitsy Spider)
6. London Bridge is falling down

7. The Mulberry Bush
8. Ring a ring o' roses
9. Row row row your boat
10. The wheels on the bus
11. Wind the bobbin up
12. Jack be nimble
13. Jack and Jill
14. The grand ol' duke of York

Task Specific Music

If you are fortunate enough to have a piano and musician accompanying your classes you are blessed with the freedom to control all musical aspects of your class. But most teachers teaching pre ballet are equipped with a stereo system that plays cds, and or mp3. Task specific music refers to music written with a specific dance task in mind. We are all familiar with the inordinate number of children's ballet class cds available. Most of it focuses on standard ballet exercises such as plies, tendu, port de bras and a range allegro music. However there are others that provide tracks for changes in musical pitch and assist in developing crescendos of movement. Carefully chosen songs can transform a quite ordinary exercise to something thrilling for children. Some songs are composed to work with concepts such as pitch and speed. These are ideal for exercises that offer the children the chance to accelerate from walking, to skipping, to running; all in one concise musical work. Similarly there are songs that are designed to introduce a theme to children. Songs that are based on themes such as the seasons; Spring Winter Autumn and Summer, help teachers organise a term of material. Festive songs such as those that cover Christmas and Easter can all contribute to fun, well organised classes.

Good ballet class music will help children build a more intimate relationship with ballet. It can assist in the introduction of famous ballets and their equally famous musical scores. When music is specifically designed for children, often the compositions are reduced to a format that is structurally accessible for children. The music is less atonal, it tends to highlight the more rhythmical sections of a musical score and the length is abbreviated. Often the length of the music is composed to suit specific ballet exercises. The music from Swan Lake, Giselle, The Nutcracker and Coppelia are instantly recognisable to children who regularly attend ballet lessons. This is not because they have been to the ballet and are familiar with the librettos, it is because simple versions of

the musical scores are used in class. This is an ingenious introduction to celebrated ballet music without children being overwhelmed by the complexity of musical scores.

Using such music provides teachers with the ideal opportunity to discuss music and give a very basic synopsis of its source and ballet narrative. This work can be consolidated with child friendly literature either downloaded from the internet or ballet story books also designed for children. A recent innovation allows ballet story books to play music when they are opened or a button pressed inside the book. Children are delighted by these additions and they help to bring the story books to life. These tentative introductions to works of ballet can be broadened by organising theatre trips to see ballets specifically designed for children.

Expressive Mime

Mime is a wonderful activity for ballet pupils. Children are very well adapted to 'play pretend' and for most create make believe scenarios on a regular basis. Left to their own devices a four year old will create imaginary friends to talk to, fabricate a make believe scenario and behave as though her fantasy world is as real as the one the rest of us inhabit. She may be deeply involved in developing characters for her toys, and creating fantastic adventures. In this world the child is happy and stimulated. In this world a child begins to understand the world she lives in. She elects to represent her world in make believe. However, it is in these play scenarios that children are able to develop all the skills necessary for expressive mime.

Mime teaches children how to act out a narrative with the use of movement and gestures. This is very attractive for children because it is this environment that they inhabit on a regular basis. Mime for children is no different to the imaginary worlds they build on a regular basis when left to entertain themselves. If you point to the ceiling and say "look up there, how many apples you can see in the tree?" they will provide you with an answer. You may even be surprised by the extent to which they will expand on a simple cue for mime. Children love to mime. Place an imaginary crown on your head, curtsey gracefully and then ask your class "who am I?" All hands will eagerly shoot up and say "you're the Queen!" Ask "who would like to be Queen today?" A frenzy of wagging will hands dart into the air hoping to be chosen. Most children do not suffer the awkward embarrassment that adults suffer when prompted to enter the world of make believe. Children happily enter this world with few inhibitions.

Expressive mine has a wealth of benefits for children in ballet. Most significantly, it allows children to respond to a dance activity on their own terms. It gives them the chance to express movement in their own unique way. If for instance you ask children to go jumping in muddy puddles, you will get a variety of frenzied jumps and a wealth of information about puddles when asked. It gives children the opportunity to express their world as they see it. Sometimes you are given apparently unrelated confusing information. But you can be sure on some level that information makes sense.

Traditional ballet is a dance form characterised by narrative, mime, music and scenery. The inclusion of mime introduces children to a distinctive feature of ballet theatre. Simple ballet gestures such as me, you, beauty, dance, the queen, promise, etc. can all be learned by children? Create a mime based on these

simple traditional ballet gestures and you will keep children engaged throughout class. In addition, make up some of your own mime gestures or better still invite your pupils to create their own. Children will happily participate in these activities. The Inclusion of mime cards in class are an interesting variation on a theme. Print off some interesting activity cards and then invite the children to re-enact the scenarios through mime. In addition you could ask the children to present their own mime scenarios totally unaided. Mime classes are always a success. For older children pick a short mime excerpt from a well-known ballet to create a stimulating and educational activity for class. It connects ordinary class material to real ballets and as such renders greater credibility to class content. In addition it is useful to keep abreast of the ballet season in your town. Take the opportunity to teach a mime excerpt from a ballet in season and then organise a school outing to see the ballet production. These classes can also be set for future shows and recitals.

Another note to remember is that some of the national awarding bodies require mime solos as part of the assessment process. As such mime classes are good preparation for these assessments whether taken in the near or distant future.

Mime scenarios for class

1. Walking through the garden picking flowers
2. Playing in muddy puddles
3. Daisies and butterflies (two groups)
4. Eating dinner
5. Reading a book and bringing the story to life
6. Buzzing bees and butterflies
7. Who will buy my pretty flowers? (flower prop needed)
8. At the seaside
9. Growing flowers into blossom
10. Sleeping pixies waking in the morning
11. Building a doll with a toymaker
12. Mice eating cheese behind a sleeping cat who eventually wakes up
13. Looking into the duck pond
14. Waking up in the morning

15. Picking apples from a tree
16. Taking the lift
17. Going for a picnic
18. Opening presents at Christmas
19. Little Miss Muffet (nursery rhyme)
20. Getting ready for ballet

Story Telling

Children love storytelling, and whilst it is true that children come to a pre ballet class to dance, there is nothing wrong with time dedicated to storytelling.

Storytelling is a form of entertainment that has been with us for centuries. Children are captivated by the characters, the pictures and love being taken on a narrative journey. Storytelling can ignite the imagination of children and draw them in emotionally. But for pre ballet, storytelling has numerous benefits. It can bring characters to life and form a solid foundation for learning about ballet productions.

The most famous ballets are available in story book form. Using books is an ideal way to introduce ballets such as Swan Lake, Sleeping Beauty, Coppelia and The Nutcracker. Storybooks can be simply read aloud to children referencing the pictures intermittently. Alternatively, the text can be ignored completely making use of the pictures exclusively to introduce the characters and narrate the story. The pictorial method is particularly enjoyable as children automatically want to contribute to the tale and ask questions to satisfy their infinitely inquiring minds. They are extremely adept at visualising stories and are keen to embellish them. Storytelling provides a gateway to understanding ballet and its content in a way that is very accessible to children. This is conceivably one of the most successful ways to teach young children the wonderful stories in ballet. Storytelling can be supplemented by visits to the theatre especially where ballets have been specifically reworked for a child audience. Children are thrilled when they are able to recognise characters on stage and mesmerised when the story they have studied comes to life before them. Telling ballet stories from books prepares children for theatre performances with a coherent understanding of the ballet. This improves the enjoyment of attending theatre and increases enthusiasm for further theatre visits

Once a story has been told, ballet music can be introduced in class for additional learning. It is better in the early stages to use edited music that has been composed especially for children's ballet classes. These compositions simplify ballet scores that could overwhelm children by their complexity. Suitable ballet music could be combined with ballet mime in class to gain an overall

understanding of ballet productions and is a fun way to bring a ballet story book to life. Using books, music, mime vocabulary and theatre visits can provide an altogether panoramic understanding of how ballet stories evolve.

It should be noted that young children enjoy having stories told to them repeatedly. It is the need for repetition that makes the stories told to them extremely influential as children accept all aspects of the stories mostly without filter. For ballet pupils this means that the use of story books could contribute to ballet learning in a very significant way and determine the ways in which children think about ballet.

In a world awash with mass media technology it is refreshing to allow children to enter into a world of make believe. Traditional ballet typically presents to us simple stories of good against evil where the bad is ultimately subordinated by the good. Such stories teach children to think about right and wrong behaviour and the ramifications of both. Children learn about consequences and learn some of our inherent cultural values. These concepts are beneficial in helping children understand our norms and values. They also allow children to reflect upon their own personal conduct and general modes of behaviour. Often for children, the division between reality and fantasy is blurred. Eating a pretend ice cream is only marginal to eating a real one, and in the absence of shop bought ice-cream a make believe one will do.

Use of Props

Children love using props in their ballet classes. Props help keep children engaged and contribute to the development of their own creativity. Teachers often include props in the preparation of class material for a variety of reasons. Here are some of them. They can be used to reduce the qualms of a recently registered child in class, or form the basis for a newly choreographed dance. But left to their own devices, children are equally as capable of creating a scenario with a scarf, teddy bear or any other prop laid before them.

Props are a wonderful resource for teachers. They help with class management and the creative process. A child who attends class for the first time may experience pangs of anxiety and feel the absence of her mother's presence. She is disquieted by the new faces and the unfamiliar surroundings that characterise a dance studio. But a child's sense of alienation can be alleviated by permitting a teddy bear that she owns to watch her class. A familiar toy taken from home can aid in settling a child in a new class. Told that Teddy is looking after her while Mummy is away can have a significant impact on easing first day blues. And whilst the teddy should not become a regular participant in the class, he can help to maintain a happy creative environment that could be impaired by an intermittently weeping child.

Teddies and dollies can be used to control talking and generally distractive behaviour. Tell the children to look at teddy. "See how quiet he is. He is waiting for you to be quiet too!" The children will look at the exemplary behaviour demonstrated by teddy and be motivated to do the same. Using teddy as a behaviour management tool can be used periodically in class. Take care not to overuse this method as gradually it will become less effective.

Teddies and dollies can be placed between each child during circle time. This will help maintain a fairly sized circle where placement spots are not being used. In addition placing teddies in between children can help control the scramble of pupils rushing to sit next to the 'popular girls' or teacher.

Dollies and Teddies can be introduced as friends who have come to see a ballet show in class. Ask the children to bring their own special teddies and dollies to class on a special date; perhaps following the completion of a little dance routine. Tell the children that their toys have been invited especially to see the dance routine that they have been working with all term. This helps children develop pride in their work and look forward to this special event. Alternatively, the teacher could surprise the pupils by stating that some special friends have

come to see their show. Either scenario is exciting for three to five year olds and creates a frenzy of anticipation at the start of class.

Most children love bouncing balls. Use them in conjunction with clearly pulsating music to develop co-ordination. With each beat of the music get the children to bounce the ball at the appropriate time. Even the most timid of children will be enticed to join in where balls are being tossed to and thro. Use brightly coloured balls with music as a first stage. Next, mime the same game by removing the balls and encourage children to behave as though the balls are still there. Final stage, develop a story around this simple exercise. Use ballet steps, mime and suitable music.

Scarves are the bedrock of pre ballet classes because of their versatility. They can be used to assist in teaching technical steps such as temps lié and most weight transitioning steps. Allow the scarves to float up as the weight of the body is transferred from one foot to the other. Then allow the scarves to waft down as the body lowers into plié. Using the scarf can help emphasise the contrasting downward motion of plié as opposed upward transitioning of body weight from one foot to the other. The scarves can be used to accentuate swinging, spinning and swaying movements in choreography. Alternatively wands and ribbons can be used in scenarios similar to those used with scarves. Wands can create fantasy and are ideal for dance narratives based on wizards, witches and magic. Used in conjunction with a crown, wands can help to portray a queen, a princess help to depict a castle scenario and all stories related to royalty.

For three year olds give each child a scarf and ask them to throw the scarf into the air and catch it before it lands on the floor in front of them. Older students can perform a similar exercise by catching the scarves whilst running to a specially chosen piece of music. Use music that encourages the children to co-ordinate the tossing and catching of scarves in time with the music. Basic galloping or skipping sequences across the studio can be revived with the use of two long flowing scarves held in both hands. A bridge or tunnel, can be constructed with scarves. Create fun choreography by asking the children to skip along under the bridge in pairs, or crawl along the floor of a tunnel individually. Introduce grand jeté by creating a bridge made of scarves. Ask the children to jump over the bridge and curtsey at the end. Scarves may be used to develop fluidity in arms and used to perform butterfly runs or birds flying in the sky. The use of scarves is infinite.

Bean bags can be used in ballet classes to develop good posture. Place a bean bag on top of the heads of each child and ask them to perform a regal Queen's

walk from one end of the studio to the other. Increase the challenge of a grand jeté by progressively increasing the height of bean bags piled on top of each other. Bean bags can also be used to assist in class management. Place bean bags across the studio floor at equal distance. These can be used to space the children out into even lines across the studio. Create interesting pathways for children to follow for travelling sequences. Align bean bags together in close proximity to create a bed for Sleeping Beauty, a river for Swan Lake or simply to demarcate the division between off stage and on stage in rehearsals.

During free time or improvisation sessions place a range of props in front of the children and invite them to choose one. Select children individually by identifying those who are best behaved. This will encourage others to follow suit and improve behaviour in the class as a whole. Play the music and leave the children to use the props however they deem fit. Alternatively ask each child about the prop they have selected. Three to five year olds will easily create a story if prompted by a series of questions. This freedom of expression should be encouraged throughout the term. Unfortunately this creative predisposition is slowly lost and replaced by logic and common sense if not nurtured.

Dance Games

Play is an intrinsic part of a child's developmental process. It is the means through which they learn about the world around them and how they fit in. Games represent a microcosm of the real world. Children learn about rules, patterns of behaviour, what fun feels like and how to interact with others. With these significant benefits, (and many more) pre ballet lessons would be missing a vital learning element without them.

When a child becomes competent in playing a game she has confirmed her ability to learn, understand and demonstrate. By her enthusiasm to participate in a game, we know she enjoys it. In very basic terms this is precisely what teachers aspire to in pre ballet classes. Teachers want children to have fun and learn rudimentary aspects of ballet and to be able to demonstrate that knowledge in performance. It is very rewarding for teachers when children are keen to return to class week after week, term after term.

With this in mind, it makes sense to include games in class on a regular basis. Games should not be randomly selected but should have attributes that assist in developing the qualities and skills needed in dance. Games should make children feel good about themselves, and at the same time expose children to some of the criteria necessary for dance study. Games that develop children's dance vocabulary are fun and simultaneously educational. . Games that use words such as stop, go, jump and freeze are of benefit to ballet pupils. Games that teach children to care and show empathy for others should also be included; Musical Hugs springs to mind. Children delight in games like Bumper Cars and learn spatial awareness and develop listening skills. Consider those games that teach discipline and observance to rules; they are of immense value in a pre ballet class. Musical lines teach children the contrast between order and disorder. Concepts of challenge and competition are evident in elimination games such as Musical Statues, and Upstage Downstage. From these children are given the opportunity to experience the exhilaration of success and discover ways to attain it. When children play Limbo it teaches them bodily control, how to challenge the limits of their own ability and how to wait and take turns.

Depending on the games selected, games can provide many of the necessary skills to assist children in creative movement and pre ballet. They are a good supplement to standard ballet classes and provide a welcomed relief when ordinary class material becomes tedious. They can perk children back up and give them a boost to continue a previous task or embark upon a new one.

However, games should be used sparingly in class; perhaps one each week giving preference to the ones that are most popular. If children find something dull, they will not want it repeated. Even the most recalcitrant of children will want to join in when they observe their peers having fun. When children are playing games, they are relaxed and more receptive to new ideas. This is a fertile setting to present new ideas, concepts and tasks. Games can help reduce the resistance sometimes expressed by children to new challenging material. Because games make children relaxed they are less likely to steer away from tasks when their abilities are challenged.

Games in ballet make lessons a fun place to be. It gives children another reason to attend class. And although the games may not be recognised as ballet, children will warm to the fun and excitement these games engender in class.

Dance Games Directory

1. Mirroring
First gather the children to form a circle. The teacher invites all pupils to copy her various gestures, facial expressions and jumps. The children are then separated into pairs taking turns in performing each other's movements and facial expressions.
2. Parachute Game
This is probably a game for slightly older children as it requires a fair degree of trust. You will need a large piece of cloth upon which one child lies still in the centre. The rest of the group, take hold of the parachute and slowly lift it off the floor and then slowly take it down.
3. Detective
A child is given the role of detective and is asked to leave the room. In her absence one child Is selected to be the instigator of a range of movements performed by the rest of the group. When the detective re-enters the room, her job is to find out who is initiating the movements. The movements can be ballet based or ordinary every day gestures.
4. Flying Birds
The teacher calls out a series of birds that fly upon which the group is required to fly around the room. Each time the teacher calls out something that does not fly, the group is required to stand still with arms folded. Those who continue to fly are eliminated. This is a good game to develop fluidity in the arms.
5. Name Gestures

Form a circle. Each child is asked to represent her name in movement terms. The rest of the group are asked to copy the movement. The more outlandish the movements the more fun is derived from the exercise. The exercise is performed by each child in the group

6. Old McDonald
Sing the traditional song with the alteration 'and on that farm he had an arm, eieio, with a shake up here and a shake down there, here a shake, there a shake everywhere a shake, shake. Etc.... Replace traditional lyrics with a variety of body parts and dance terms

7. Busy Bee
Children improvise around the studio pretending to buzz around like bumble bees. When the music stops, each must run to find another to hook into: back to back elbows interlocked.

8. Sleeping Fairies
Select a piece of music of your choice and ask the class to dance around the studio. One of the children is the Sleeping fairy, and when she blinks to her friends they have to fall asleep until nobody is dancing.

9. Limbo
Children are challenged to shunt under a bar with torso upwards. The bar is lowered each round making the task progressively more difficult.

10. Walking With a Beanbag
Each child is given a small bean bag to place on their head. The aim is to walk the length of the studio without the bean bag falling off their heads. Practice leading with pointed feet and arms in demi seconde

11. Memory tester
Have all the children line up facing the studio mirrors. One child is removed from the group. She is asked to move to a position where she cannot see the rest of the class. The rest of the children are required to take a pose and hold it. The selected child returns to look at all her fellow pupils for 15 seconds. The group then sit down. The Selected child is asked to reassemble all the children according to the movements previously performed.

12. Movements are numbers
Take a range of movements and assign each movement a number. Call out the numbers randomly. The children are required to perform the associated movements accordingly.

13. Clapping your name
Form a circle within which each child claps their Names. The number of claps is subject to the number of syllables in their names.

14. Magic Scarves

 Place a number of coloured scarves around the room. The children improvise whilst the music is playing. When the music stops, the teacher calls a colour to which all the children run to. The number of colours called at any time is unrestricted.

15. Musical Hoops

 This is an alternative to musical chairs. The children are required to run to fit into hula hoops when the music stops. Each time one hoop is eliminated making the game increasingly difficult.

16. Upstage Downstage

 Familiarise the children with the stage directions, upstage, downstage, stage right, stage left and centre stage. When the teacher calls a stage direction, the children are required to run to that place. Centre stage calls for children to sit on the floor in the centre.

17. Basket weaving

 Form a large standing circle. Have one child weave in front of and behind the group until they arrive back in their own spot. This can be done, walking, running, skipping with the use of music

18. Musical Hugs

 Children are asked to perform a range of dance movements to music. When the music stops, the children run randomly to hug each other. This is a very good game for welcoming new children. Another version of this game is Freeze. Each time the music stops the children are required to stand still until the music starts again.

19. The Sleeping Toymaker

 The setting is in a toymaker's studio where he makes dolls. When the music is playing the toymaker is asleep and all the dolls wake up and dance. When the music stops, the toymaker wakes up, the dolls have to be perfectly still until he falls asleep again. A little mime is required from the teacher to animate this exercise

20. Traffic Lights

 This exercise is similar to the game movements are numbers. Like the ordinary everyday traffic lights there are three; red, amber and green. Each colour is given a movement. For instance green may mean sauté, amber ballerina walks and red, curtsey. There are multiple ways in which this can be utilized; to learn arm positions, feet positions and facial expressions.

21. Hungry Mice

 Children start down stage. Explain that they are mice hiding in the wall

and they are very hungry. There is a cat guarding their cheese. The aim of the game is to tiptoe slowly past the cat and collect the cheese without being spotted. Any object can be used to represent the cheese. The child who gets the cheese assumes the role of the cat.

22. Simple Simon Says

 This exercise can be used to test the pupils' knowledge. The teacher says "Simple Simon says.......plié" for instance and the children are required to demonstrate plié. This game can be played with or without elimination as a result of the errors the pupils make.

23. Musical Lines

 This is a version of musical chairs. The children dance when the music is playing but when the music stops, they form a line. This a good game to develop class organisation for the very young

24. Charades

 This game is charades for children designed to improve or introduce mime skills. The group forms a circle and each child is given a facial expression to mime in front of the group. These assignments can be made more complicated for older children.

25. Hide and Peek

 Children are grouped into pairs. One child stands behind the other. Upon a command from the teacher (or another child) the child behind pops a body part into view and then retracts upon another command

26. March and balance

 Similar to musical chairs children balance on one leg when the music stops.

27. Popcorn

 Have children form a line facing the mirror. The teacher taps the head of a child to which she responds with a sauté. This can be made more difficult by encouraging the children to jump to a certain height. To do this simply hover your hand over the child's head dictating the height of the jump

28. Bumper Cars.

 Give each child a hula hoop and tell them to hold it around their waist. Explain that this is a motor car and they should not touch any other pupil's car.

 With music give the children directions such as stop, go, stand up and sit down. When they touch another pupil's car, they are eliminated.

Routine and Repetition

Routine and repetition is considered to be one of the cornerstones of dance teaching. It is through repeating an exercise over and over that it becomes part of a regular routine. It is the repetition of a routine that builds muscle memory; the brain's ability to retrieve muscular motor movements and replicate it with greater ease and success.

For children, routine and repetition are extremely important. Whilst the above applies equally to children, there are a variety of other factors that make repetition and routine vital for children. Too much change creates a sense of instability and children are left feeling uncomfortable because they don't know what to expect. This is apparent when a little girl of three years old is brought to a ballet class for the first time. She is desperately clinging to her mother's legs because everything is so unfamiliar. She is afraid of the unknown. It is only over time when everything feels more familiar that attending class will be less fraught and anxious.

A class where the content is predictable is very attractive to children. Repetition for a child represents familiarity, stability and subsequent security. It is through recurrence that a child learns how to perform actions with confidence. The more familiar an action is, the more proficient a child becomes in that action. This success engenders confidence in a child's ability to learn current material and any new tasks thereafter. It is through the success of achievement that the child begins to feel safe, and secure enough to embark on new challenges. A child will become trusting in an environment that has permitted her to excel.

In a class where a child can feasibly anticipate its content, a child is able to relax because she understands her environment. She is able to predict the outcomes of her effort and will be keen to participate. Typically children love to feel independent and in control of their activities. Presenting a child with a class constantly changing in content will reduce a child's keenness to participate because by not knowing what to expect she will experience accumulating anxiety. This seeming sense of not understanding will cause a child to withdraw for fear of failure. This situation complicates a teacher's ability to teach with

success and can create a needlessly antagonistic relationship between pupil and teacher.

Children will enjoy a class where success is attainable. They will look forward to participating in class and will be less confrontational. Pupils will feel a greater sense of self control which will reduce the perception that teacher is a 'bully' imposing unobtainable, unattractive exercises upon them. It is very satisfying for children to know 'what comes next' in class and to be able to tell the teacher so. Children instinctively enjoy things being repeated. This is evident in the unending desire of children to have the same story book read at bed time every night. Monotonous though it may seem, each time the same book is read, the child is discovering different aspects of the book. This may be reviewing an understanding of the vocabulary, getting a greater insight into the characters or consolidating an overall understanding of the book. Children are learning each time a book is read over. In a pre ballet class the employment of regular repetition and routine provides the same learning opportunity. Over time children become competent and understand class material well. This contributes to a healthy class with happy, confident pupils and a fulfilled teacher where class runs smoothly. As such repetition and routine is a crucial teaching method in class.

Repetition and routine is important for children to learn. However, this does not mean that material should never be altered. If the same exercises are practised without exception the brain will not be stimulated and learning will eventually stagnate. Children will also become bored. Change should be subtle and gradual for children to reap the benefits. Opt to combine two known elements with a different song perhaps. Perform a task with a change of pace. In general children love acceleration and deceleration; doing things faster and faster and then slowing down only speed up again. Utilise this to present an old activity with a new sheen. Similarly change the order of an enchainement to present a different challenge with the same material. Create a dance narrative using all known dance steps together to a piece of music or add some fun props to known sequences. In most scenarios, scarves are easily integrated into dance motifs. In all events a change in content should not be overwhelming. Let children know in advance that they will be doing something slightly different so they will be

emotionally ready for change. This will also create an exciting atmosphere of anticipation.

New material should ignite a spark of excitement and prompt a keenness to try. This approach will keep ballet lessons fun, sufficiently challenging and a safe environment for children discover new ideas.

Flexible Teaching

For decades ballet has been a taught with the main aim of teaching the art form. At the forefront, the intention has been to prepare children to graduate from one level of ballet to another with perhaps the ultimate progression to professional training. However, the large majority of children who attend ballet classes may not aspire to become ballerinas. They may be attending class because of the well-established social, artistic and cognitive benefits ballet has to offer. With the range of pupils attending classes and the plethora of motives for doing so, ballet would serve its recipients best if it were to review its curriculum with a consideration of pupil centred methods.

Today, prescriptive teaching methods are considered out dated and on the whole unsuitable for the 21st century. Children today are more confident and bursting with ideas and opinions. The contemporary dance teacher needs to be receptive to the personal contributions that children make in class. And whilst the very young may utter many unrelated things at times in class, this can be managed within circle time. In addition some of the things little ones say can be very endearing and provide a unique glimpse of a burgeoning personality. These little utterances help the teacher to become better acquainted with her pupils. Allowing older pupils the opportunity to participate in the development of their learning gives them a sense of self-reliance; skills very much needed in their lives outside of the dance studio. Also, they are able to develop a sense of ownership of their classes which will improve attendance for longer lengths of time.

Ballet teachers today need to be flexible in their approach to teaching. It helps to understand pupils rather than simply disseminate material to them. A child for instance may opt not to participate in class, and this could be for a variety of reasons. But failing to know your pupils could lead to a misunderstanding of the behaviours being presented and the child being dismissed as an antagonistic and a difficult child. Sometimes a child may just want to be left alone for a moment or by contrast be pining for attention.

Ballet teachers should give praise not just for the things done well but for the attempts to do so. This acknowledgement will encourage children to work harder with assignments in general but give extra attention to the exercises they

are struggling with. For three year olds teachers can give praise for sitting with legs crossed or for listening attentively. For all pre ballet lessons positive comments should be given to the attempts and effort pupils make in class and for any suggestions and ideas they put forward. These suggestions may be creative, critical or intellectual.

On occasion a well-conceived class plan may not be received as well as anticipated. In such situations, the best option might just be to abandon it entirely. But before doing so it might be fruitful to elicit opinions from the class. At first this may feel as though you do not have the full command of your subject. On the contrary, to get feedback from your pupils shows your interest in their enjoyment of class and gives you an indicator of the kind of lesson you might plan the next time. It gives you assurances that you are meeting the needs of your class and reduces the closeted murmurings of dissatisfaction that as a teacher you are not often privy to. Dialogue and feedback are essential if needs meeting is part of the aims of a modern pre ballet programme. Communication with the children and parents is needed if nothing is to be missed.

Plan classes that allow for spontaneous adjustment if need be. Generally teachers plan more material than is needed, but it might be useful to consider the level of complexity in planned class material. In preparation, teachers are not entirely sure whether the material is too difficult or too easy until it is presented in class. When creating an enchainement for class, look at the ways that it could be simplified or embellished if needed. Try to avoid those uncomfortable moments where the children are left feeling defeated because the material is too complicated. Worse still make sure you are not left stretching material out to fit the time slot for class because the children completed the tasks well ahead of time.

Ballet should no longer be a place where the teacher dictates and the children obey. In line with current educational trends, ballet classes should be open to discussion, modification and negotiation. It should be a fun place where the needs of children are carefully considered and parents are made comfortable when offering suggestions and feedback.

Instilling Confidence in Pupils

One of the greatest benefits of a child attending dance classes is the confidence she develops over time. Dance is quite demanding of its participants and the struggles to achieve success can at times appear overwhelming. But it is through the struggles that dance presents to a child that she is able to build self-esteem, worth and confidence.

Self-confidence is a developmental process. Very few people are naturally self-confident. It is something that is nurtured through experience both internally and externally. Each time a child is presented with a task that is unfamiliar, her self-confidence and ability is called to question. The child who refuses to participate in a class activity may be struggling with self-image and her ability to perform successfully that which is being asked of her. She may be riddled with self-doubt and fear failure. Rather than risk humiliation she elects to opt out.

With the rigors of ballet especially in mind, it is important to present class material in a manner that is accessible to children. Self-confidence is easily destabilised when material appears to be too demanding and or unsuitable for the age group. Too many attempts at a task that is beyond the natural abilities for a given age will over time damage a child's self confidence in ballet. She will become less motivated, perhaps come to dislike ballet and eventually drop out completely. On the contrary a teacher who presents a fun, manageable, syllabus will be contributing to instilling the confidence that is so necessary in ballet. As such one of the primary roles of a teacher is to equip pupils with the belief that they can dance, they can learn ballet, and they can rise to a challenge. This is achieved through selective, appropriate ballet content.

Each time a child is presented with material that is feasible, she is being bestowed with the confidence to learn without self-doubt, to trust her own abilities and to confront that which she perceives to be potentially beyond her reach. Each time the outcome of her travails is positive her self-esteem and self-reliance is elevated.

Throughout the learning process it is important to provide encouragement and support for children. Negative comments only serve to harm self-worth and should be avoided at all costs. Allow a child the opportunity to study material at a pace she can manage. For instance when a child finds a particular allegro challenging offer alternatives of approach; break the material down further, make the pace slower, allow more learning time. At all costs avoid the child leaving class feeling deflated and defeated.

It is important to compliment the creative and expressive qualities that a child exhibits in ballet and not focus wholeheartedly on the development of technical ability. The younger a child is the less likely she will be able to perform ballet technique with accuracy. Teachers should look at the overall development and draw positive to attention the myriad of things being achieved in class. This might include self-discipline, social skills, improved conduct and self-presentation. All of these components have immense value in assessing a child's overall progress in ballet. In this way a child's confidence is maintained even if her dancing ability is not comparable to others in her class.

Teachers should consider giving praise to small achievements in class. This might include arriving on time if punctuality is normally an issue. A child who speaks for the first time in class may have struggled with the confidence to do so. It is right to thank that child for her contribution in the hope that more contributions may follow. Give positive feedback when a pupil tries to correct the errors she makes in class. The first time a three year old's curtsey is performed taking one leg to the back instead of the front deserves praise. For many three year olds this is a huge achievement and warrants attention. Give reward stickers in class and try to find the positives in each child when doing so. Children need to know what they are doing well otherwise they lose the momentum to improve.

When praising a child it is important to be specific. Children who are frequently told that they 'did well' or that they are 'naturally talented', are less likely to work with real levels of conviction. They assume their talents are natural and therefore hard work is unnecessary. They do not know what has been done well so they conclude all is great. It is not sufficient to tell a child that she has performed well in class. In order to develop her confidence and a good working ethic, she needs to know precisely what things were done well. Draw attention to the improved elevation in a sauté for instance. Thank a child for pointing her toes beautifully. Did she respond to the request to be quiet?

If so desired a teacher will be able to find a variety of things in class that will contribute to the development of high self-esteem and confidence in children. She simply needs to go looking for them and they will be there in abundance.

A curriculum for teaching ballet creatively

A curriculum refers to all the components that form the contents of an educational programme. It dictates what is to be taught, how it is taught and how often. In preparing a curriculum it is important to know what the goals of the curriculum are. Once the goals of the curriculum have been established, the ways in which the goals are achieved will become apparent.

Pre ballet can be taught from a variety of perspectives. Traditionally it is taught from a subject centred perspective where the teacher is responsible for disseminating ballet content with the expectation that the data will be assimilated over a set time frame. Some of these preparatory programmes are exam based whereas others adopt a less academic approach. However, there are a range of elements that might warrant inclusion in a modern day pre ballet curriculum. These are character building attributes that aid the personal development of the child in class. It is fair to say that ballet, like many dance programmes by its very nature contributes to the development of teamwork skills, self-discipline, social integration and confidence to name a few. But often these things are peripheral side benefits that occur as a by-product of dancing. They are not part of a consciously conceived module included in the inception of curriculum design. To maximise the benefits of ballet participation, the curriculum design should include as a core ingredient specific concepts devoted to personal growth and development. The programme should actively seek to include games, improvisation and opportunities where children are able to articulate their own opinions and to contribute to class content from time to time. It is not being suggested that children be entirely responsible for their own learning, but in situations where choice and decision making permit, children should be given the reins.

As such a creative ballet curriculum should offer pupils the opportunity to develop an understanding of ballet as a form of personal expression and a performing art. It should seek to develop the personal as well as the professional providing all participants with the skills to achieve either or both. The curriculum should cater to the needs of all its recipients and reflect in its content elements that serve to meet the various motivations for ballet attendance.

In effect this means that ballet is not taught exclusively from a subject centred stance but enjoys a blend of subject, teacher and student centred methods. Concepts of discussion, and choice, sit alongside prescription and have an influential impact on the overall character of the programme. As such pre ballet

pupils are able to enjoy a diverse programme with process oriented concepts working in concert with product based components.

Some things to consider for a pre- ballet curriculum:
1. Length of programme
 In terms of weeks, terms or years
2. Duration per class unit
 One, two three hours per week
3. Level of programme
 Beginners, elementary pupils
4. Location
 Venue accessibility
5. Venue
 Health and safety
6. Anticipated cost of programme
 Standard rates, concessions, modes of payment
7. Certification and assessment
 Rad, UKA, ITDA, ISTD, BBO. Internal validation
8. Syllabus development
 Process of level differentiation and advancement
9. Entry requirements
 Entry level, beginners, previous experience
10. Discursive components
 Group discussion, individual expression, critical thinking, and cognitive development
11. Ballet composition
 Choreography with and without props
12. Public performance
 Programmed dance recitals
13. Creative expression

Free dance and improvisation with and without props, personal growth
14. Ballet technique
 Observance of a prescribed ballet syllabus
15. Entertainment
 Recreational games, theatre visits
16. Behaviour management
 Class conduct, ballet norms and values
17. Evaluation
 Feedback, consideration of strengths and weakness
18. Revision
 Opportunities for curriculum modification.

This list is by no means exhaustive. It represents a starting point. Teachers and those designing curricular programmes will more than likely find additional things to include. What is significant is that whatever the curriculum, it provides pupils with an engaging programme where they are fulfilled artistically, emotionally, socially and intellectually.

Suggested Resource Material

Music

Kimbo Educational Music and Movement for Children

Music for Movement and Imaginations: Ballet Class & Creative Movement (for Children Ages 3 and Up) Richard Maddock

Musical Gems XVI Creative Movement for Pre-Ballet Class Craig Wingrove

Music Works

Pre Ballet Dance Programmes (Non-regulated)

4 Dancem

Pre Ballet Syllabi

Maria's Movers Dance Curriculum

Regulated Awarding Bodies

RAD

ISTD

IDTA

UKA

NATD

CDTA

CECCHETTI

** Inclusion does not equal endorsement*

Bibliography

White, John, *Teaching Classical Ballet* University Press of Florida 1996
Lawson Joan, *The teaching of Classical Ballet* A&C Black Limited 1977
Boross, Rosemary, *Ballet Beginnings for Children*, Princeton Book Company 2008
Newman, Judith, *How to teach Beginning Ballet*, Princeton Book Company 2012
Newman, Barbara, *The Illustrated Book of Ballet Stories*, Dorling Kindersley Book
McCaughrean, Geraldine, *Stories From The Ballet*, Orchard Books, 2003
Manthorp Beryl F, *Towards Ballet*, Dance Books 1980
Evans, Gina, *The 1st Three Years of Dance* Amazon
Dancing, Royal Academy, *Step By Step Ballet Class,* Contemporary Books, 1994
Alliance, United Kingdom *Ballet Grades1-8*, UKA
IDTA. *Theatre Dance Syllabus*, International Dance Teachers Association Limited 2014

Kindle Publications

Evans, Gina, *How To Teach Pre-School Ballet: A guidebook for teachers*, Mayer Arts Inc. 2011
Crouch Chery Ann, *Teaching Dance A Dance Teaching Methodology Book*, Cheryl Ann Crouch

Author

Judy John-Baptiste founded The Basement Dance studio in 1997, a dance studio based in the heart of London offering a wide range of dance classes to adults and children. She studied dance formally at Trinity Laban and gained a Master's degree in Performance Art Middlesex University. Her general education in dance was completed at Surrey University where she acquired a post graduate certificate of education. She has a professional coaching diploma and provides career related coaching to professional artists.

Ms John-Baptiste has worked as a choreographer, performer but has extensive experience as a dance teacher. She has written several dance courses which have received national accreditation with OCN a national awarding body in the UK. She teaches grade classes in ballet and jazz to children and adults in London alongside writing dance related texts.

Other books include: *Allie's First Ballet Exam* and *Allie's Ballet Alphabet*

For updates, and all related information please go to the website: www.teachingballetcreatively.com

www.ingramcontent.com/pod-product-compliance
Lightning Source LLC
Chambersburg PA
CBHW070428180526
45158CB00017B/930